TEXAS
TOTAL ECLIPSE GUIDE

Official Commemorative
2024 Keepsake Guidebook

2024 Total Eclipse State Guide Series

Aaron Linsdau

SASTRUGI PRESS

JACKSON HOLE

Sastrugi Press / Published by arrangement with the author

Texas Total Eclipse Guide: Official Commemorative 2024 Keepsake Guidebook

The author has made every effort to accurately describe the locations contained in this work. Travel to some locations in this book is hazardous. The publisher has no control over and does not assume any responsibility for author or third-party websites or their content describing these locations, how to travel there, nor how to do it safely. Refer to local regulations and laws.

Any person exploring these locations is personally responsible for checking local conditions prior to departure. You are responsible for your own actions and decisions. The information contained in this work is based solely on the author's research at the time of publication and may not be accurate in the future. Neither the publisher nor the author assumes any liability for anyone climbing, exploring, visiting, or traveling to the locations described in this work. Climbing is dangerous by its nature. Any person engaging in mountain climbing is responsible for learning the proper techniques. The reader assumes all risks and accepts full responsibility for injuries, including death.

Sastrugi Press
PO Box 1297, Jackson, WY 83001, United States
www.sastrugipress.com
Quantity sales: Special discounts are available on quantity purchases by corporations, associations, and others. For details, contact the publisher at the address above.

Library of Congress Catalog-in-Publication Data
Library of Congress Control Number: 2017917793
Linsdau, Aaron
Texas Total Eclipse Guide / Aaron Linsdau-1st United States edition
p. cm.
1. Nature 2. Astronomy 3. Travel 4. Photography
Summary: Learn everything you need to know about viewing, experiencing, and photographing the total eclipse in Texas on April 8, 2024.

ISBN-13: 978-1-944986-23-0 (Paperback)
ISBN-13: 978-1-64922-029-5 (Hardback)

508.4—dc23

All photography, maps and artwork by the author, except as noted.

10 9 8 7 6 5

Contents

Introduction

Thank you for purchasing this book. It has everything you need to know about the total eclipse in Texas on April 8, 2024.

A total eclipse passing through the United States is a rare event. The last US total eclipse was in 2017. It traveled from Oregon to South Carolina. The last American total eclipse prior to that was in 1979!

The next total eclipse over the US will not be until April 8, 2024. It will pass over Texas, the Midwest, and on to Maine. After that, the next coast-to-coast total eclipse will be in 2045.

It's imperative to make travel plans early. You will be amazed at the number of people swarming to the total eclipse path. Some might say watching a partial versus a total eclipse is a similar experience. It's not.

This book is written for Texas visitors and anyone else viewing the eclipse. You will find general planning, viewing, and photography information inside. Should you travel to the eclipse path in Texas in April, be prepared for an epic trip. The estimates based on the 2017 eclipse suggest that millions will converge on Texas.

Some hotels in the communities and cities along the path of totality in Texas have already been contacted by people to make reservations. Finding lodging along the eclipse path may be a major challenge.

Resources will be stretched far beyond the normal limits. Think gas lines from the late 1970s. It may be likely that traffic along highways will come to a complete standstill during this event. Be prepared with backup supplies.

Many smaller Texas towns are far from any major city. Texas country roads can be slow. Please obey posted speed limits for the safety of everyone. Be cautious about believing a map application's estimate of travel time in Texas.

People in all communities along the path of the total eclipse may rent out their properties for this event. With this major celestial spectacle in the spring of 2024, be assured that Texas "hasn't seen anything yet."

Is this to say to avoid Texas or other areas during the eclipse? Not at all! This guidebook provides ideas for interesting, alternative, and

memorable locations to see the eclipse. It will be too late to rush to a better spot once the eclipse begins. Law enforcement will be out to help drivers reconsider speeding.

Please be patient and careful. There will be a large rush of people from all over the world, converging on Texas to enjoy the total eclipse. Be mindful of other drivers on eclipse weekend, as they may not be familiar with Texas roads.

You should feel compelled to play hooky on April 8. Ask for the day off. Take your kids out of school. They'll be adults before the next chance to see a total eclipse over America. Create family memories that will last a lifetime. Sastrugi Press does not normally advocate skipping school or work. Make an exception because this is too big an event to miss.

Wherever you plan to be along the total eclipse path, leave early and remember your eclipse glasses. People from all around the planet will converge on Texas. Be good to your fellow humans and be safe. We all want to enjoy this spectacular show.

Visit www.sastrugipress.com/eclipse for the latest updates for this state eclipse book series.

Author Information

Polar explorer and motivational speaker Aaron Linsdau's first book, *Antarctic Tears*, is an emotional journey into the heart of Antarctica. He ate two sticks of butter every day to survive. Aaron coughed up blood early in the expedition and struggled with equipment failures. Despite the endless difficulties, he set a world record for surviving the longest solo expedition to the South Pole.

Aaron teaches how to build resilience to overcome adversity by managing attitude. He shares his techniques for overcoming adrenaline burnout and constant overload. He inspires audiences to face their challenges with a new perspective. Aaron builds grit, teaches courage, and shows how to deal with uncontrollable change. He hopes that you will be inspired and have an enjoyable time watching the total eclipse in Texas.

Visit his website at www.aaronlinsdau.com.

All About Texas

OVERVIEW OF TEXAS

Travelers head to the state of Texas to experience what residents already know. The state of Texas has beautiful natural resources, exciting cities, and a never-ending supply of big, Texas fun. Texas is the second-largest state in the United States. Located in the south-central United States, it's a good place to view the eclipse on April 8, 2024.

If you love natural beauty, travel to Texas Hill Country or to a cattle ranch on the Texas plains. Take a trip to Big Bend National Park, or enjoy one of the state's many lakes. If you just need a day at the beach, head to Galveston or Corpus Christi. You may even get to snap a family photo sitting in fields of the state's famed bluebonnets flowers.

The state has many local, state, and national parks. Each park offers a number of amenities for outdoor enthusiasts of all kinds such as nature walks, fishing, camping, and spending time with family and friends.

If cities are your style, Dallas, Austin, and Houston provide the latest fashions and trends in dining, shopping, and socializing. For history lovers, there's the Alamo and the rich history of Dallas. Learn about US Presidents with a trip to the libraries of George H. Bush, George W. Bush, and Lyndon B. Johnson. The perfect tie-in for the eclipse will be to visit NASA outside Houston. Plan well in advance.

Whether your great Texas road trip ends in a city or the plains, you're sure to make lifelong memories as you venture out on Texas roads. Texas is a leader in energy production and many other businesses and industry. That means growing, vibrant cities and a buzz of excitement throughout the entire state.

Of course, no trip to Texas is complete without the food. Enjoy

genuine Tex-Mex from a variety of world-class restaurants throughout the state. There are chain restaurants that are all Texas like Whataburger and Chuy's, or you can take advantage of one-of-a-kind eateries that dot the state. And it isn't just Tex-Mex either. Texans love food from a variety of genres.

Whether you're in a small town or one of the big cities, there's a unique and unforgettable dining experience waiting for you. In Texas, there's something for everyone. Go camping and enjoy bird watching, fishing, and hiking. Stay in a modern hotel and take in a show or sporting event. Amusement parks like Six Flags Over Texas in Arlington are an option too.

Remember to buy a cowboy hat and a pair of boots. You can do it all in the Lone Star State. Texans are friendly, and they're eager to show you what's so great about their state. Texas has a number of professional sports teams. From the famed Dallas Cowboys to the championship San Antonio Spurs, the Houston Texans and the Texas Rangers, you're never far from the chance to join in the fun.

The Lone Star State is also home to a number of world-renowned universities, including the University of Texas, Texas A&M, Southern Methodist University, and Texas Tech. Texans love to share their experiences. They're proud of their rich and diverse history.

Texas has a robust infrastructure, so it's easy to travel in and around the state. Each city has a major airport that can accommodate a traffic surge. Most of the major airports are traveler friendly whether you plan to rent a car or take advantage of the city's public and private transportation network. Even though residents are proud of their cars and trucks, you can navigate a trip to a Texas city without a vehicle if you're determined to do it. If you plan to use a car, you have the entire state of Texas within reach.

With a mild climate much of the year, it's always a good time to visit Texas. In the spring, the Texas wildflowers start to bloom and the color returns to the plains. Beautiful fall days bring warm sunshine and football games. At any time of the year, you can make Texas memories both outside and inside.

Plan to tour the state before, during, and after the eclipse for an experience that you won't soon forget. The only challenge is choosing

between the endless options. Whether you love the city or the country, the great outdoors or indoor activities like shopping, shows or clubs, there's something for everyone. Get ready for a big Texas welcome as Texas says "Howdy" to you.

HOTELS AND MOTELS DURING THE ECLIPSE

Once excitement of the total eclipse over Texas spreads, rooms will become scarce. Many hotels in towns along the path of totality in western states sold out for a year or more during the 2017 total eclipse. Texas is not alone in this challenge. Hotels all along the path of totality will sell out in anticipation of the 2024 total eclipse.

What does this mean for eclipse visitors? Lodging and room rentals in eclipse towns will be at a massive premium. Does that mean all hope is lost to find a place to stay? Not at all. But you will have to be creative. There will be few, if any, hotel rooms available in these eclipse cities by early 2024. Accommodations in the cities and towns along the path of the eclipse will be difficult to come by.

In summer 2017, the author searched on Hotels.com for rooms along the 2017 total eclipse path on the weekend of August 21 and found many major cities sold out. Once word of the 2024 eclipse spreads, room rates will increase and availability will drop.

Search for rooms farther away from the eclipse path. If you are willing to stay in cities outside the eclipse path, you will have better success at finding rooms. As the eclipse approaches, people will book rooms farther from the totality path. By early spring, rooms in cities near the total eclipse path may be unavailable. The effect of this event will be felt across Texas and the rest of the United States.

Think regionally when looking for rooms. Be prepared to search far and wide during this major event. If a five-hour drive is manageable, your lodging options greatly expand, but it also increases your travel risk.

INTERNET RENTALS

To find rooms to stay in towns along the eclipse path, try a web service such as Airbnb.com. Note that some people rent out rooms or homes illegally, against zoning regulations. Cities will feel the crunch of inquiries early due to others who experienced the 2017 eclipse.

If cities fully enforce zoning laws, authorities may prevent your weekend home rental. Online home rentals during the eclipse will be a target for rental scams. People from out of the area steal photos and descriptions, then post the home for rent. You send your check or wire money to a "rental agent" then show up to find you have been scammed. If the deal sounds strange or too good to be true, run away.

CAMPING

If you can book a campsite, do it as soon as you can. Do not wait. All areas in the national forests are first-come, first-served. Forest roads may be packed. Expect all areas to be swarming with people. Show up early to stake out your spot. Consider staying farther away and driving early on April 8.

Please respect private land too. Texas folks don't take kindly to people overrunning their property without permission. In a big state with millions of residents, people are very protective, but they're friendly, too. You never know what you might be able to arrange with a smile and a bit of money.

This all said, there are plenty of camping opportunities throughout Texas. You don't have to sleep exactly on the eclipse path. If you're ready to rough it, there are national forest camping options.

Government agencies will meet years in advance to talk about how to manage the influx of people. Every possible government agency will be working full time to enforce the various rules and regulations.

NATIONAL PARKS AND MONUMENTS

Finding a camping site at any state park, national park, or national monument along the eclipse path in Texas will be challenging. To watch the eclipse from any location, you do not have to sleep in it. You just need to drive there in the morning.

Law enforcement will be present on the eclipse weekend. Hundreds of thousands of people are expected in the region. Parking may overflow. It will make parking lots and lines on Black Friday at the mall look uncrowded. For an event of this magnitude, find your location as early as possible.

The first sentence of the national parks mission statement is:

"The National Park Service preserves unimpaired the natural and cultural resources and values of the national park system for the enjoyment, education, and inspiration of this and future generations."

TEXAS

Roadside camping (sleeping in your car) is not allowed in national monuments or parks. Park facilities are only designed to handle so many people per day. Water, trash collection, and toilets can only withstand so much. If you notice trash on the ground, take a moment to throw it away. Protect your national park and help out. Rangers are diligent and hardworking but they can only do so much to manage the expected crowds.

NATIONAL FORESTS AND WILDERNESS

There are national forest options in Texas. They all have camping opportunities. The forest service manages undeveloped and primitive campsites. Be sure to check for any fire restrictions. Check with individual agencies for last-minute information and regulations. The forest service requires proper food storage. Plan to purchase food and water before choosing your campsite. Below is a partial list of national forests along or near the total eclipse path:

Angelina NF:
www.fs.usda.gov/recarea/texas/recarea/?recid=30200
Davey Crocket NF:
www.fs.usda.gov/detail/texas/about-forest/districts/?cid=fswdev3_008441

Backcountry service roads abound in Texas. Maps for forests are available at local visitor centers and bookstores. This book's website has digital copies of some forest maps.

Printed national forest maps are large and detailed. They have illustrated road paths, connections, and other vital travel information not available on digital device maps. Viewing digital maps on your smartphone or mobile pad is difficult. If you plan to camp in the forest, a real paper map is a wise investment.

Camping in federal wilderness areas is also allowed. Those areas afford the ultimate backcountry experience. However, be aware that no vehicle travel is allowed in the specially designated areas. This ban includes: vehicles, bikes, hang gliders, and drones. You can travel only on foot or with pack animals.

Sleep in Your Car

Countless RVs, campers, trucks, cars, and motorcycles will flood Texas. Sleeping in your car with friends is tolerable. Doing so with unadventurous spouses or children is another matter.

Do not be caught along the path of the total eclipse without some sort of plan, especially in the bigger cities of Texas. The whole path of totality will fill with people on April 8.

Useful Local Webcams

Local webcams are handy to make last-minute travel decisions. Modern webcams are sensitive enough to show headlights at night. Use them to determine if there are issues before traveling out. Eclipse traffic will add to the morning commuter traffic.

There are smartphone applications which are useful to check webcams in many locations. Consult your device's app store for the latest updates. Whether you use an app or computer, an Internet search will reveal many handy webcams for your eclipse planning.

Weather

It's all about the weather during the eclipse. Nothing else will matter if the sky is cloudy. You can be nearly anywhere along the path of totality in Texas and catch a view of the sky when traffic comes to a standstill. But if there's a cloud cover forecast, seriously reconsider your viewing location.

Travel early wherever you plan to go. Attempting to change locations an hour before the eclipse due to weather will likely cause you to miss the event. Texas country roads can be narrow and slow. The number of vehicles will cause unexpected backups.

MODERN FORECASTS

Use a smartphone application to check the up-to-date weather. Wunderground is a good application and has relatively reliable forecasts for the region. The hourly forecast for the same day has been rather accurate for the last two years. The below discussion refers to features found in the Wunderground app. However, any application with detailed weather views will improve your eclipse forecasting skills.

CLOUD COVER FORECAST

The most useful forecast view is the visible and infrared cloud-coverage map. Avoid downloading this app the night before and trying to learn how to read it. Practice reading them at home. It's imperative to understand how to interpret the maps early.

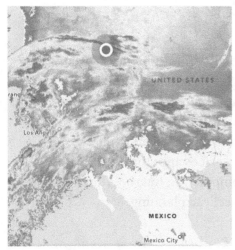

Infrared cloud map showing the worst case eclipse cloud cover.
Courtesy of National Weather Service.

All cloud cover, night or day, will appear on an infrared map. Warm, low-altitude clouds are shown in white and gray. High-altitude cold clouds are displayed in shades of green, yellow, red, and purple. Anything other than a clear map spells eclipse-viewing problems.

To improve your weather guess, use the animated viewer of the cloud cover. It will give you a sense of cloud motion. You can discern whether clouds or rain are moving toward, away from, or circulating around your location.

NORMAL TEXAS WEATHER PATTERN

Due to the direction of the jet stream, most weather travels across the Pacific Ocean, through the western states, over the Rockies, and then into Texas. On occasion, weather can approach from Mexico or off the Gulf of Mexico. Due to the nature of the tropical storms from

the Atlantic, weather in Texas can be unpredictable.

The common weather pattern in April is moderately warm in the afternoon and cool in the evenings. Passing cold fronts in spring can bring unexpected cloud cover and rains.

Historically, Texas tends to have cloud cover during April. Prepare to make adjustments. If anything other than clear skies are predicted, plan to drive to other parts of Texas, Arkansas, or Oklahoma.

Be aware of tornadoes in Texas. Although the peak tornado season is June, there have been many recorded tornadoes in April. Pay attention to the weather forecast. If dangerous weather is predicted, your main concern should be safety rather than chasing an eclipse.

Consider that slow-moving clouds can obscure the sun for far longer than the four-minute duration of the totality. The time of totality is so short that you do not want to risk it. Missing it due to a single cloud will be a major disappointment.

Local Eclipse Weather Forecasts

Local town and city newspapers, radio, and television stations around Texas will have a weekend edition with articles discussing the eclipse weather. However, conditions change unpredictably in Texas. A three-day forecast may be incorrect.

Finding the Right Location to View Eclipse Effects

One of the peculiarities of total eclipses is that the entire show is not only in the sky. There are other unusual effects seen during the total eclipse that are worth looking for.

The first effect to watch for is the crescent moon shapes created from leaf shadows on the ground. 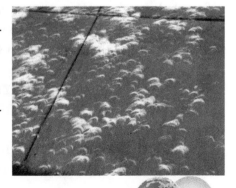 They're best viewed on a sidewalk or asphalt. They can only be observed during the partial eclipse. The other effect that is worth watching for is the shadow bands or "snakes" as they're commonly called.

Shadow banding is seen right

before and after the totality takes place. They're best observed on smooth, plain-colored surfaces. If you plan to be in the forest for the eclipse, you may struggle to see the bands but will likely see crescent shadows all around on the ground.

One of the supreme challenges with all of these effects is choosing what to watch. You can see the crescent shadows in the hour before and after the totality but shadow banding happens before or after totality. It is more difficult to look away from the total eclipse than you think.

Road Closures and Traffic

Highways connecting various Texas towns in the total eclipse path will be heavily impacted on the weekend before and day of the eclipse. As was found in the 2017 total eclipse, there is no way to predict which areas will be impacted.

Planning ahead is essential to give you the best opportunity to enjoy the eclipse without the nightmare of being stuck in traffic for hours on end. The traffic in states during the 2017 eclipse was stunning, so imagine what it will be like for Texas in 2024.

Update yourself with the latest road report information from the Texas road condition website:

Check the Texas road report for updated information:

drivetexas.org

It's imperative to plan for fires and their effects. Watch the weather reports. If strong winds and lightning storms are forecast, prepare to change your viewing location. If conditions are poor, you and thousands of other vehicles will be trapped in slow-moving traffic.

If you believe it's necessary to leave a town to watch the eclipse, do so the night before or extremely early in the morning. RVs are common, and trains of them crawl through popular areas.

Texas Information

Cellular Phones

Cellular "cell" phone service in remote Texas locations may be problematic. Most of the time there is good coverage along the main

highways and interstates. However, even along major thoroughfares, there can be little or no coverage.

It's possible to find zones where text messages will send when phone calls are impossible. If you cannot make a phone call, the chance of having data coverage for web surfing or e-mail is low.

Please look up any information or communicate what you need before departing from the main roads around Texas. Bureau of Land Management (BLM) areas sometimes have coverage. Planned to be self-contained. Treat your cell phone like it won't connect.

You may find yourself out of cell service. With a large number of cell users in a concentrated area, coverage and data speed may collapse as well. Search on the phrase "cell phone coverage breathing".

Wilderness and Forest Safety

All Texas deserts and wilderness areas are full of wild animals. Although beautiful, wild animals can be dangerous. They can easily injure or kill people, as they are far more powerful than humans. Do not try to feed any wild animals, including squirrels, foxes, and chipmunks, as they can carry diseases. These suggestions apply to all public lands.

FERAL HOGS

Introduced in the early twentieth century, hogs have become a major problem in Texas. Although they tend to flee when encountered, hogs have been known to attack people. They can be aggressive and their tusks can inflict serious wounds. There have been instances of deaths, too. It is best to leave these animals alone if you encounter one.

ALLIGATORS

Although the chance of encountering an alligator is low, it is not uncommon to encounter them. With hurricanes moving significant quantities of water in recent years, alligators may be in unexpected locations. If you encounter one, back away from the animal and contact fish and game if it poses a threat.

VENOMOUS SNAKES

There are multiple species of venomous snakes in Texas including the Timber Rattlesnake, Copperhead, Coral Snake, and Cottonmouth. Although these reptiles are not generally aggressive, they can strike when provoked or threatened. Of the approximately 8,000 people annually bitten by venomous snakes in the United States, ten to fifteen people die according to the U.S. Food and Drug Administration.

The best way to avoid rattlesnake encounters is to be mindful of your environment. Do not place your hands or feet in locations where you cannot clearly see the surroundings. Avoid heavy brush or tall weeds where snakes hide during the day. Step on a log or rock rather than over it, as a hidden snake might be on the other side. Rattlesnakes may not make any noise before striking.

Avoid handling all snakes. Should you be bitten, stay calm and call 911 or emergency dispatch as soon as possible. Transport the victim to the nearest medical facility immediately. Rapid professional treatment is the best way to manage rattlesnake bites. Refer to US Forest Service and professional medical texts for more information on managing rattlesnakes injuries.

TICKS

Ticks exist all across the United States but not all species transmit disease. Ticks cannot fly or jump, but they climb grasses in shrubs in order to attach to people or animals that pass by. Ticks feed on the blood of their host. In doing so, they can transmit potentially life-threatening diseases such as Lyme disease.

According to the National Pesticide Information Center, ticks must be attached and feed for several hours before an infection can be passed. Do not wait that long to manage tick exposure. As soon as you travel through outdoor locations, especially in grasses or shrubs, check yourself for ticks. They can be incredibly small and difficult to detect. Some are smaller than the head of a pin.

You may wish to consider wearing tick-specific insect repellent. Check with your doctor or medical professional about any potential adverse side effects of chemical repellents.

Should you discover an attached tick, follow modern tick removal

methods. There are many incorrect tick removal methods found on-line. Refer to your medical professional for proper removal methods. Improper removal increases the likelihood of an infection.

Mountain Lions

Though listed as extinct in the state, there have been recent reports of mountain lions in Texas. If you encounter a mountain lion, do not run. Keep calm, back away slowly, and maintain eye contact. Do all you can to appear larger. Stand upright, raise your arms, or hoist your jacket. Never bend over or crouch down. If attacked, fight back.

TEXAS

Eclipse Day Safety

1. Hydrate

Spring temperatures are usually mild to warm. The excitement of the event can distract you from managing hydration. Drink plenty of water. Consume more than you would at home.

2. Eye Safety time

Use certified eclipse safety glasses at all times when viewing the partial eclipse. Only remove the glasses when the totality happens. Give your eyes time to rest. They can dry out and become irritated. Bring FDA approved eye drops to keep your eyes moist.

3. Sun exposure

Facing at the sun for three hours can result in sunburns. Wear sunglasses and liberally apply sunscreen to avoid sunburns.

4. Eat well

Keep your energy up. Appetite loss is common when traveling. Maintain your normal eating schedule.

5. Prepare for temperature changes

Temperatures will drop rapidly during the eclipse and also once the sun sets. Bring appropriate clothing.

6. Talk with your doctor

If the humidity or heat bothers you talk with your doctor before traveling. Seek professional medical attention for serious symptoms.

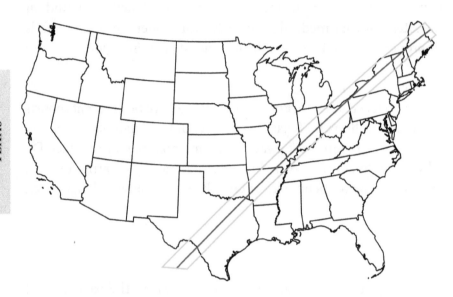

Total eclipse path across the United States (approximate).

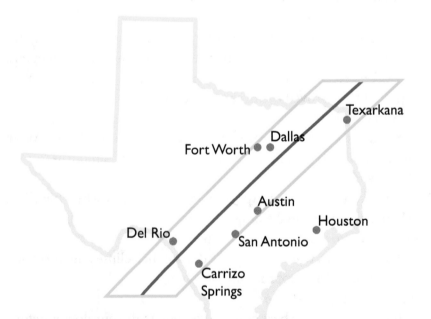

All About Eclipses

HOW AN ECLIPSE HAPPENS

An eclipse occurs when one celestial body falls in line with another, thus obscuring the sun from view. This occurs much more often than you'd think, considering how many bodies there are in the solar system. For instance, there are over 150 moons in the solar system. On Earth, we have two primary celestial bodies: the sun and the moon. The entire solar system is constantly in motion, with planets orbiting the sun and moons orbiting the planets. These celestial bodies often come into alignment. When these alignments cause the sun to be blocked, it is called an eclipse.

For an eclipse to occur, the sun, Earth, and moon must be in alignment. There are two types of eclipses: solar and lunar. A solar eclipse occurs when the moon obscures the sun. A lunar eclipse occurs when the moon passes through Earth's shadow. Solar eclipses are much more common, as we experience an average of 240 solar eclipses a century compared to an average of 150 lunar eclipses. Despite this, we are more likely to see a lunar eclipse than a solar eclipse. This is due to the visibility of each.

For a solar eclipse to be visible, you have to be in the moon's shadow. The problem with viewing a total eclipse is that the moon casts a small shadow over the world at any given time. You have to be in

ECLIPSES

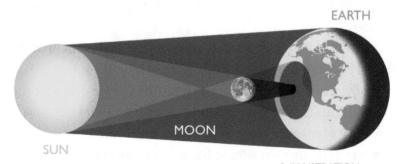

EARTH

MOON

SUN

* ILLUSTRATION
NOT TO SCALE

a precise location to view a total eclipse. The issue that arises is that most of these locations are inaccessible to most people. Though many would like to see a total solar eclipse, most aren't about to set sail for the middle of the Pacific Ocean. In fact, a solar eclipse is visible in the same place on the world on average every 375 years. This means that if you miss a solar eclipse above your hometown, you're not going to see another one unless you travel or move.

It's much easier to catch a glimpse of a lunar eclipse, even though they occur at a much lower frequency than their solar counterparts. A lunar eclipse darkens the moon for a few hours. This is different than a new moon when it faces away from the sun. During these eclipses, the moon fades and becomes nearly invisible.

Another result of a lunar eclipse is a blood moon. Earth's atmosphere bends a small amount of sunlight onto the moon turning it orange-red. The blood moon is caused by the dawn or dusk light being refracted onto the moon during an eclipse.

Lunar eclipses are much easier to see. Even when the moon is in the shadow of Earth, it's still visible throughout the world because of how much smaller it is than Earth.

TOTAL VS. PARTIAL ECLIPSE

What is the difference between a partial and total eclipse? A total eclipse of either the sun or the moon will occur only when the sun, Earth, and the moon are aligned in a perfectly straight line. This ensures that either the sun or the moon is partially or completely obscured.

In contrast, a partial eclipse occurs when the alignment of the three celestial bodies is not in a perfectly straight line. These types of eclipses usually result in only a part of either the sun or the moon being obscured. This is often what led to ancient civilizations believing that some form of magical beast or deity was eating the sun or the moon. It appears as though something has taken a bite out of either the sun or the moon during a partial eclipse.

Total eclipses, rarer than partial eclipses, still occur quite often. It's more difficult for people to be in a position to experience such an event firsthand. Total solar eclipses can only be viewed from a small portion of the world that falls into the darkest part of the moon's shadow. Often this happens in the middle of the ocean.

THE MOON'S SHADOW

The moon's shadow is divided into two parts: the umbra and the penumbra. The former is much smaller than the latter, as the umbra is the innermost and darkest part of the shadow. The umbra is thus the central point of the moon's shadow, meaning that it is extremely small in comparison to the entire shadow. For a total solar eclipse to be visible, you need to be directly beneath the umbra of the moon's shadow. This is because that is the only point at which the moon completely blocks the view of the sun.

In contrast, the penumbra is the region of the moon's shadow in which only a portion of the light cast by the sun is obscured. When

<div align="right">ECLIPSES</div>

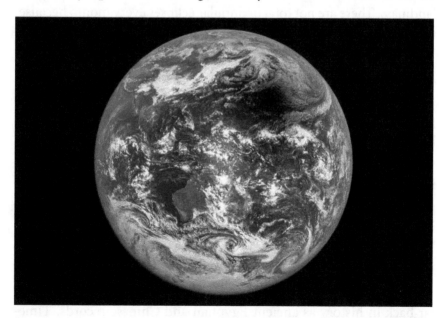

Total eclipse shadow 2016 as seen from 1 million miles on the Deep Space Climate Observatory satellite. Courtesy of NASA.

ECLIPSES

standing in the penumbra, you are viewing the eclipse at an angle. In the penumbra, the moon does not completely block the sun from view. This means that while the event is a total solar eclipse, you'll only see a partial eclipse. The umbra for the April 8 eclipse is over one hundred miles wide. The penumbra will cover much of the United States, Canada, and Mexico.

To provide some context, one previous total solar eclipse we experienced occurred on March 9, 2016, and was visible as a partial eclipse across most of the Pacific Ocean, parts of Asia, and Australia. However, the only place in the world to view this total solar eclipse was in a few parts of Indonesia.

Due to the varied locations and the brief periods for which they're visible, it's difficult to see each and every eclipse that occurs. The umbra of the moon is such a small fraction of the entire shadow and the majority of our planet is comprised of water. Thus, the rarity of being able to view a total solar eclipse increases significantly because it's likely that the umbra will fall over some part of the ocean rather than a populated landmass. There are not total or annular eclipses every month because the moon's orbit is 5.1° off the ecliptic plane of the Earth and sun.

ECLIPSES THROUGHOUT HISTORY

Ancient peoples believed eclipses were from the wrath of angry gods, portents of doom and misfortune, or wars between celestial beings. Eclipses have played many roles in cultures, creating myths since the dawn of time. Both solar and lunar eclipses affected societies worldwide. Inspiring fear, curiosity, and the creation of legends, eclipses have cast a long shadow in the collective unconscious of humanity throughout history.

EARLY MYTH & ASTRONOMY

Documented observations of solar eclipses have been found as far back in history as ancient Egyptian and Chinese records. Timekeeping was important to ancient Chinese cultures. Astronomical

observations were an integral factor in the Chinese calendar. The first observation of a solar eclipse is found in Chinese records from over 4,000 years ago. Evidence suggests that ancient Egyptian observations may predate those archaic writings.

Many ancient societies, including Roman, Greek and Chinese civilizations, were able to infer and foresee solar eclipses from astronomical data. The sudden and unpredictable nature of solar eclipses had a stressful and intimidating effect on many societies that lacked the scientific insight to accurately predict astronomical events. Relying on the sun for their agricultural livelihood, those societies interpreted solar eclipses as world-threatening disasters.

In ancient Vietnam, solar eclipses were explained as a giant frog eating the sun. The peasantry of ancient Greece believed that an eclipse was the sign of a furious godhead, presenting an omen of wrathful retribution in the form of natural disasters. Other cultures were less speculative in their investigations. The Chinese Song Dynasty scientist Shen Kuo proved the spherical nature of the Earth and heavenly bodies through scientific insight gained by the study of eclipses.

ECLIPSES

The Eclipse in Native American Mythology

Eclipses have played a significant role in the history of the United States. Before Europeans settled in the Americas, solar eclipses were important astronomical events to Native American cultures. In most native cultures, an eclipse was a particularly bad omen. Both the sun and the moon were regarded as sacred. Viewing an eclipse, or even being outside for the duration of the event, was considered highly taboo by the Navajo culture. During an eclipse, men and women would simply avert their eyes from the sky, acting as though it was not happening.

The Choctaw people had a unique story to explain solar eclipses. Considering the event as the mischievous actions of a black squirrel and its attempt to eat the sun, the Choctaw people would do their best to scare away the cosmic squirrel by making as much noise as

possible until the end of the event, at which point cognitive bias would cause them to believe they'd once again averted disaster on an interplanetary scale.

CONTEMPORARY AMERICAN SOLAR PHENOMENA

The investigation of solar phenomena in twentieth-century American history had a similarly profound effect on the people of the United States. A total solar eclipse occurring on the sixteenth of June, 1806, engulfed the entire country. It started near modern-day Arizona. It passed across the Midwest, over Ohio, Pennsylvania, New York, Massachusetts, and Connecticut. The 1806 total eclipse was notable for being one of the first publicly advertised solar events. The public was informed beforehand of the astronomical curiosity through a pamphlet written by Andrew Newell entitled *Darkness at Noon, or the Great Solar Eclipse.*

This pamphlet described local circumstances and went into great detail explaining the true nature of the phenomenon, dispelling myth and superstition, and even giving questionable advice on the best methods of viewing the sun during the event. Replete with a short historical record of eclipses through the ages, the *Darkness at Noon* pamphlet is one of the first examples of an attempt to capitalize on the mysterious nature of solar eclipses.

Another notable American solar eclipse occurred on June 8, 1918. Passing over the United States from Washington to Florida, the eclipse was accurately predicted by the U.S. Naval Observatory and heavily documented in the newspapers of the day. Howard Russell Butler, painter and founder of the American Fine Arts Society, painted the eclipse from the U.S. Naval Observatory, immortalizing the event in *The Oregon Eclipse.*

Four more total solar eclipses occurred over the United States in the years 1923, 1925, 1932, and 1954, with another occurring in 1959. The October 2, 1959, solar eclipse began over Boston, Massachusetts. It was a sunrise event that was unviewable from the ground level. Em-

inent astronomer Jay Pasachoff attributed this event to sparking his interest in the study of astronomy. Studying under Professor Donald Menzel of Williams College, Pasachoff was able to view the event from an airline hired by his professor.

To this day, many myths surround the eclipse. In India, some local customs require fasting. In eastern Africa, eclipses are seen as a danger to pregnant women and young children. Despite the mystery and legend associated with unique and rare astronomical events, eclipses continue to be awe-inspiring. Even in the modern day, eclipses draw out reverential respect for the inexorable passing of celestial bodies. They are a reminder of the intimate relationship between the denizens of Earth and the universe at large.

PRESENT DAY ECLIPSES

The year 2017 brought the world's most-watched total eclipse in history on August 21, when a total solar eclipse crossed the United States. An annular eclipse, a "ring of fire," will pass over the United States in 2023 from Oregon to Texas. Though impressive, it will not

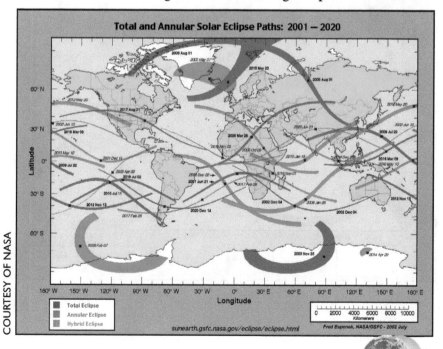

COURTESY OF NASA

ECLIPSES

compare to the 2024 total eclipse. There is little in nature that equals the spectacle of the sun's corona and seeing stars in the day.

There will be multiple partial, annular, or hybrid eclipses across the world before the 2024 total eclipse. However many are in remote, inaccessible, or potentially dangerous locations on the globe. In 2019 and 2020, Chile and Argentina will experience total eclipses. The next total eclipse after that will occur over Antarctica in 2021. An extremely rare hybrid eclipse will happen in 2023 over the Indian Ocean, Australia, and Indonesia.

The next total solar eclipse viewable from the United States will occur on April 8, 2024. It will be visible in fourteen states: Texas, Oklahoma, Arkansas, Missouri, Kentucky, Illinois, Indiana, Ohio, Pennsylvania, Michigan, New York, Vermont, New Hampshire, and Maine.

ECLIPSES

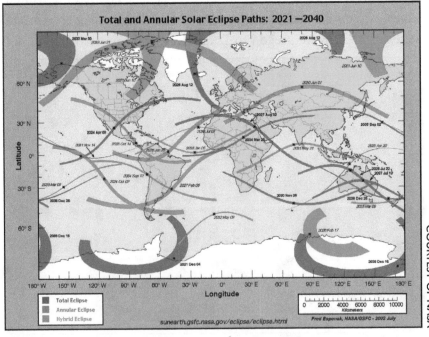

COURTESY OF NASA

Viewing and Photographing the Eclipse

AT-HOME PINHOLE METHOD

Use the pinhole method to view the eclipse safely. It costs little but is the safest technique there is. Take a stiff piece of single-layer cardboard and punch a clean pinhole. Let the sun shine through the pinhole onto another piece of cardboard. That's it!

Never look at the sun through the pinhole. Your back should be toward the sun to protect your eyes. To brighten the image, simply move the back piece of cardboard closer to the pinhole. To see it larger, move the back cardboard farther away. Do not make the pinhole larger. It will only distort the crescent sun.

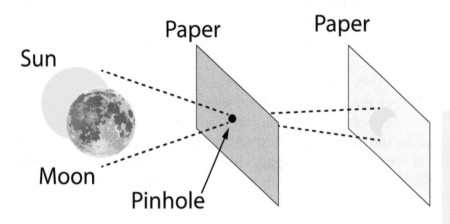

WELDING GOGGLES

Welding goggles that have a rating of fourteen or higher are another useful eclipse viewing tool. The goggles can be used to view the solar eclipse directly. Do not use the goggles to look through binoculars or telescopes, as the goggles could potentially shatter due to intense direct heat. Avoid long periods of gazing with the goggles. Look away every so often. Give your eyes a break.

SOLAR FILTERS FOR TELESCOPES

The ONLY safe way to view solar eclipses using telescopes or binoculars is to use solar filters. The filters are coated with metal

PHOTOGRAPHY

to diminish the full intensity of the sun. Although the filters can be expensive, it is better to purchase a quality filter rather than an inexpensive one that could shatter or melt from the heat.

The filters attach to the front of the telescope for easy viewing. Remember to give your telescope cooling breaks. Rapid heating can damage your equipment with or without filters attached.

Watch Out for Unsafe Filters

There are several myths surrounding solar filters for eclipse viewing. In order for filters to be safe, they must be specially designed for looking at a solar eclipse. The following are all unsafe for eclipse viewing and can lead to retinal damage: developed colored or chromogenic film, black-and-white negatives such as X-rays, CDs with aluminum, smoked glass, floppy disk covers, black-and-white film with no silver, sunglasses, or polarizing films.

Watch Out for Unsafe Eclipse Glasses

During the 2017 total eclipse, several vendors sold eclipse glasses that were not safe for viewing the sun. Although they were marketed as safe and were even marked with the ISO 12312-2 certification, they did not block eye-damaging visible, infrared, and ultraviolet light. Check the American Astronomical Society's website (eclipse.aas.org) for a list of reputable eclipse glasses vendors.

Viewing with Binoculars

When viewing the eclipse with binoculars, it is important to use solar filters on both lenses until totality. Only then is it safe to remove the filter. As the sun becomes visible after totality, replace the filters for safe viewing. Protect your pupils. Remember to give your binoculars a cool-down break between viewings. They can overheat rapidly from being pointed directly at the sun even with filters attached.

Planning Ahead

There are many things to keep in mind when viewing a total eclipse. It is important to plan ahead to get the most out of this extraordinary experience.

UNDERSTANDING SUN POSITION

All compass bearings in this book are true north. All compasses point to Earth's magnetic north. The difference between these two measurements is called magnetic declination. The magnetic declination for Texas is:

2° 40' E ± 0° 21' (for Dallas in 2024)

Adjust the declination from the azimuth bearing as given in the text, and set your compass to that direction.

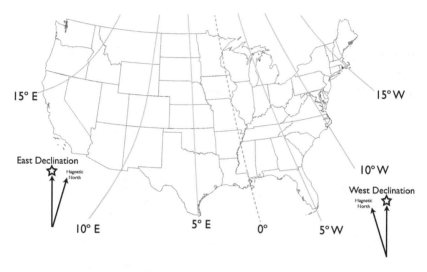

If you purchase a compass with a built-in declination adjustment, you can change the setting once and eliminate the calculations. The Suunto M-3G compass has this correction. A compass with a sighting mirror or wire will help you make a more accurate azimuth sighting.

The Suunto M-3G also has an inclinometer. This allows you to measure the elevation of any object above the horizon. Use this to figure out how high the sun will be above your position.

You can also use a smartphone inclinometer and compass for this purpose. Make sure to calibrate your smartphone's compass before every use, otherwise it might indicate the wrong bearing. Set the smartphone compass for true north to match the book. Understand the compass prior to April 8. There will be little time to guess or

PHOTOGRAPHY

search on Google. Smartphone and GPS compasses are "sticky." Their compasses don't swing as freely as a magnetic compass does.

The author has used his magnetic compass for azimuth measurements and a smartphone to measure elevation. Combining these two tools will allow you to make the best sightings possible.

Outdoor sporting goods stores in most towns and cities carry compasses. Purchase and practice with a good compass in your hometown well before the event. Take the time to learn how to use it before the day of the eclipse. You do not want to struggle with orienteering basics under pressure.

SUN AZIMUTH

Azimuth is the compass angle along the horizon, with 0° corresponding to north, and increasing in a clockwise direction. 90° is east, 180° is south, and 270° is west.

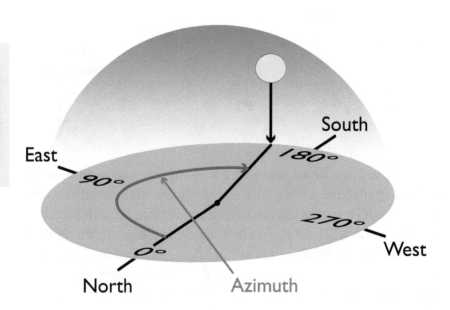

SUN ELEVATION

Altitude is the sun's angle up from the horizon. A 0° altitude means exactly on the horizon and 90° means "straight up."

Using the sun azimuth and elevation data, you can predict the position of the sun at any given time. Positions given in this book coincide with the time of eclipse totality unless otherwise noted.

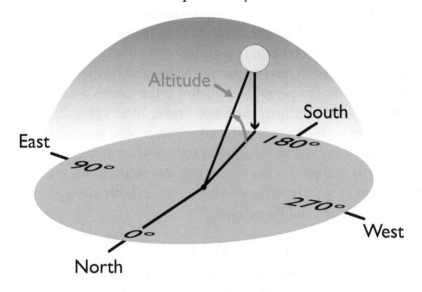

Eclipse Data for Select Texas Locations

LOCATION	TOTALITY START (CDT)	ALTITUDE	AZIMUTH
AUSTIN	1:35:59PM	67°	182°
DALLAS	1:40:38PM	64°	186°
DEL RIO	1:28:26PM	67°	169°
SAN ANTONIO	1:33:20PM	68°	178°
SULPHUR SPRINGS	1:42:51PM	64°	190°
WACO	1:37:55PM	66°	184°

Eclipse Photography

Photographing an eclipse is an exciting challenge, as the moon's shadow moves near 1,600MPH. There is an element of danger and the pressure of time. Looking at the unfiltered sun through a camera can permanently damage your vision and your camera. If you are unsure, just enjoy the eclipse with specially designed eclipse glasses. Keep a solar filter on your lens during the eclipse and remove for the duration of totality!

PHOTOGRAPHY

PARTIAL VS. TOTAL SOLAR ECLIPSE

To successfully and safely photograph a partial and total eclipse, it is important to understand the difference between the two. A solar eclipse occurs when the moon is positioned between the sun and Earth. The region where the shadow of the moon falls upon Earth's surface is where a solar eclipse is visible.

The moon's shadow has two parts—the penumbral shadow and the umbral shadow. The penumbral shadow is the moon's outer shadow where partial solar eclipses can be observed. Total solar eclipses can only be seen within the umbral shadow, the moon's inner shadow.

You cannot say you've seen a total eclipse when all you saw was a partial solar eclipse. It is like saying you've watched a concert, but in reality, you only listened outside the arena. In both cases, you have missed the drama and the action.

PHOTOGRAPHING A PARTIAL AND TOTAL SOLAR ECLIPSE

Aside from the region where the outer shadow of the moon is cast, a partial solar eclipse is also visible before a total solar eclipse within

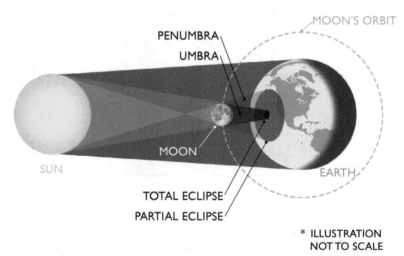

* ILLUSTRATION NOT TO SCALE

the inner shadow region. In both cases, it is imperative to use a solar filter on the lens for both photography and safety reasons. This is the only difference between taking a partial eclipse and a total eclipse photograph of the sun.

To photograph a total solar eclipse, you must be within the Path of Totality, the surface of the Earth within the moon's umbral shadow.

THE CHALLENGE

A total solar eclipse only lasts for a couple of minutes. It is brief, but the scenario it brings is unforgettable. Seeing the radiant sun slowly being covered by darkness gives the spectator a high level of anticipation and indescribable excitement. Once the moon completely covers the sun's radiance, the corona is finally visible. In the darkness, the sun's corona shines, capturing the crowd's full attention. Watching this phenomenon is a breathtaking experience.

Amidst all the noise, cheering, and excitement, you have less than a few minutes to take a perfect photograph. The key to this is planning. You need to plan, practice, and perfect what you will do when the big moment arrives because there is no replay. The pressure is enormous. You only have a short time to capture the totality and the sun's corona using different exposures.

PLAN, PRACTICE, PERFECT

It is important to practice photographing before the actual phenomenon arrives. Test your chosen imaging setup for flaws. Rehearse over and over until your body remembers what you will do from the moment you arrive at your chosen spot to the moment you pack up and leave the area.

You will discover potential problems regarding vibrations and focus that you can address immediately. This minimizes the variables that might affect your photographs at the most critical moment.

It's common for experienced eclipse chasers to lose track of what they plan to do. Write down what you expect to do. Practice it time and again. Play annoying, distracting music while you practice. Try photographing in the worst weather possible. Do anything you can to practice under pressure. Eclipse day is not the time to practice.

Once the sun is completely covered, don't just take photographs. Capture the experience and the image of the total solar eclipse in your mind as well. Set up cameras around you to record not just the total solar eclipse but also the excitement and reaction of the crowd.

ECLIPSE PHOTOGRAPHY GEAR

What do you need to photograph the total eclipse? There are only a few pieces of equipment that you'll need. Preparing to photograph an eclipse successfully takes time. Not only do you have to be skilled and have the right gear, you have to be in the correct place.

BASIC ECLIPSE PHOTOGRAPHY EQUIPMENT

- Solar viewing glasses (verify authenticity)
- Lens solar filter
- Minimum 300mm lens
- Stable tripod that can be tilted to 60° vertical
- High-resolution DSLR
- Spare batteries for everything
- Secondary camera to photograph people, the horizon, etc.
- Remote cable or wireless release

ADDITIONAL ITEMS

- Video camera
- Video camera tripod
- Quality pair of binoculars
- Solar filters for each binocular lens
- Photo editing software

EQUIPMENT TO PREPARE BEFORE THE BIG DAY

A. Solar viewing glasses

You need a pair of solar viewing glasses as the eclipse approaches.

B. Solar Filter

Partial and total eclipse photography is different from normal photography. Even if only 1% of the sun's surface is visible, it is still approximately 10,000 times brighter than the moon. Before totality, use a solar filter on your lens. Do not look at the sun with your eyes. It can cause irreparable damage to your retinas.

DO NOT leave your camera pointed at the sun without a solar filter attached. The sun will melt the inside of your camera. Think of a magnifying glass used to torch ants and multiply that by one hundred.

C. Lens

To capture the corona's majesty, you need to use a telescope or a telephoto lens. The best focal length, which will give you a large image of the sun's disk, is 400mm and above. You don't want to waste all your efforts by bringing home a small dot where the black disk and majestic corona are supposed to be.

D. Tripod

Bring a stable enough tripod to support your camera properly to avoid unsteady shots and repeated adjustments. Either will ruin your photos. It also needs to be portable in case you need to change locations for a better shot. *Shut off camera stabilization on a tripod!*

E. Camera

You need to remember to set your camera to its highest resolution to capture all the details. Set your camera to:

- 14-bit RAW is ideal, otherwise
- JPG, Fine compression, Maximum resolution

Bracket your exposures. Shoot at various shutter speeds to capture different brightnesses in the corona. Note that stopping your lens all the way down may not result in the sharpest images.

Choose the lowest possible ISO for the best quality while maintaining a high shutter speed to prevent blurred shots. Set your camera to manual. Do not use AUTO ISO. Your camera will be fooled. The night before, test the focus position of your lens using a bright star or the moon.

Constantly double-check your focus. Be paranoid about this. You can deal with a grainy picture. No amount of Photoshop will fix a blurry, out-of-focus picture.

F. Batteries

Remember to bring fresh batteries! Make sure that you have enough power to capture the most important moments. Swap in fresh batteries thirty minutes before totality.

G. Remote release

Use a wired or wireless remote release to fire the camera's shutter. This will reduce the amount of camera vibration.

H. Video Camera

Run a video camera of yourself. Capture all the things you say and do during the totality. You'll be amazed at your reaction.

I. Photo editing software

You will need quality photo editing software to process your eclipse images. Adobe Lightroom and Photoshop are excellent programs to extract the most out of your images. Become well versed in how to use them at least a month before the eclipse.

J. Smartphone applications

The following smartphone applications will aid in your photography planning: Wunderground, Skyview, Photographer's Ephemeris, Sunrise and Sunset Calculator, SunCalc, and Sun Surveyor among others.

CAMERA PHONES

Smartphone cameras are useful for many things but not eclipse photography. An iPhone 6 camera has a 63° horizontal field of view and is 3264 pixels across. If you attempt to photograph the eclipse, the sun will be a measly 30-40 pixels wide depending on the phone. Digital pinch zoom won't help here. If you want *National Geographic* images, you'll need a serious camera and lens, far beyond any smartphone.

Consider instead using a smartphone to run a time-lapse of the entire event. The sun will be minuscule when shot on a smartphone. Think of something else exciting and interesting do to with it. Purchase a Gorilla Pod, inexpensive tripod, or selfie stick and mount the smartphone somewhere unique.

Also, partial and total eclipse light is strange and ethereal. Consider using that light to take unique pictures of things and people. It's rare and you may have something no one else does.

PHOTOGRAPHY

FOCAL LENGTH & THE SIZE OF SUN

The size of the sun in a photo depends on the lens focal length. A 300mm lens is the recommended minimum on a full-frame (FF) DSLR. Lenses up to this size are relatively inexpensive. For more magnification, use an APS-C (crop) size sensor. Cameras with these sensors provide an advantage by capturing a larger sun.

For the same focal length, an APS-C sensor will provide a greater apparent magnification of any object. As a consequence, a shorter, less expensive lens can be used to capture the same size sun.

The below figure shows the size of the sun on a camera sensor at various focal lengths. As can be seen with the 200mm lens, the sun is quite small. On a full-frame camera at 200mm, the sun will be 371 pixels wide on a Nikon D810, a 36-megapixel body. A lower resolution FF camera will result in an even smaller sun.

Printing a 24-inch image shot on a Nikon D810 with a 200mm lens at a standard 300 pixels per inch results in a small sun. On this size paper, the sun will be a miserly 1.25 inches wide!

Photographing the eclipse with a lens shorter than 300mm will leave you with little to work with. Using a 400mm lens and printing a 24-inch print will result in a 2.5-inch-wide sun. For as massive as the sun is, it is a challenge to take a large photograph of the sun. The sun will appear to move fast with a 500mm lens, too. Plan to adjust.

PHOTOGRAPHY

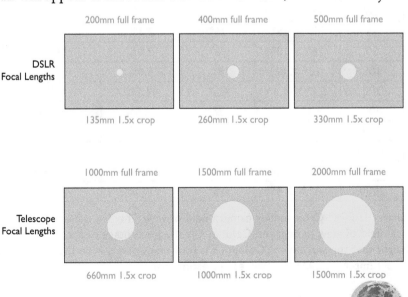

FOCAL LENGTH	FOV FULL FRAME	FF VERT. ANGLE	% OF FF	SUN PIXEL SIZE
14	104° X 81°	81°	0.7%	32.1
20	84° X 62°	62°	0.9%	41.9
28	65° X 46°	46°	1.2%	56.5
35	54° X 38°	38°	1.4%	68.5
50	40° X 27°	27°	2.0%	96.4
105	19° X 13°	13°	4.1%	200.2
200	10° X 7°	7°	7.6%	371.9
400	5° X 3.4°	3.4°	15.6%	765.6
500	4° X 2.7°	2.7°	19.6%	964.2
1000	2° X 1.3°	1.3°	40.8%	2002.5
1500	1.4° X 0.9°	0.9°	58.9%	2892.6
2000	1° X 0.68°	0.68°	77.9%	3828.4

Chart 1: Full-frame camera field of view. The 3rd column is the vertical field of view in degrees. Column 4 is the percentage of the total sensor height that the sun covers. Column 5 is how many pixels wide the sun will be on a 36MP Nikon D810. (Values are estimates)

FOCAL LENGTH	FOV CROP	CROP VERT DEG	% OF CROP	SUN PIXEL SIZE
14	80° X 58°	58°	0.9%	33.9
20	61° X 43°	43°	1.2%	45.8
28	45° X 31°	31°	1.7%	63.5
35	37° X 25°	25°	2.1%	78.7
50	26° X 18°	18°	2.9%	109.3
105	13° X 8°	8°	6.6%	245.9
200	6.7° X 4.5°	4.5°	11.8%	437.2
400	3.4° X 2°	2°	26.5%	983.7
500	2.7° X 1.8	1.8°	29.4%	1093.0
1000	1.3° X 0.9°	0.9°	58.9%	2186.0
1500	0.9° X 0.6°	0.6°	88.3%	3278.9
2000	0.6° X 0.45°	0.5°	117.8%	4371.9

Chart 2: APS-C Crop sensor camera field of view. The 3rd column is the vertical field of view in degrees. Column 4 is the percentage of the total sensor height that the sun covers. Column 5 is how many pixels wide the sun will be on a 12mp Nikon D300s. (Values are estimates)

PHOTOGRAPHY

The big challenge is the cost of the lens. Lenses longer than 300mm are expensive. They also require heavier tripods and specialized tripod heads. The 70-300mm lenses from Nikon, Canon, Tamron, and others are relatively affordable options. It is worth spending time at a local camera shop to try different lenses. Long focal-length lenses are a significant investment, especially for a single event.

To achieve a large eclipse image, you will need a long focal-length lens, ideally at least 400mm. A standard 70-300mm lens set to 300mm will show a small sun. At 500mm, the sun image becomes larger and covers more of the sensor area. The corona will take up a significant portion of the frame. By 1000mm, the corona will exceed the capture area on a full-frame sensor. See the picture in this chapter for sun size simulations for different focal lengths.

SUGGESTED EXPOSURES

To photograph the partial eclipse, the camera must have a solar filter attached. If not, the intense light from the sun may damage (fry) the inside of your camera. This has happened to the author. The exposure depends on the density (darkness) of the solar filter used.

As a starting point, set the camera to ISO 100, f/8, and with the solar filter on, try an exposure of 1/2000. Make adjustments based on the filter used, histogram, and highlight warning.

Turn on the highlight warning in your camera. This feature is commonly called "blinkies." This warning will help you detect if the image is overexposed or not.

Once the Baily's Beads, prominences, and corona become visible, there will only be a few minutes to take bracketed shots. It will take at least eleven shots to capture the various areas of the sun's corona and stars. The brightness varies considerably. No commercially available camera can capture the incredible dynamic range of the different portions of the delicate corona. This requires taking multiple photographs and digitally combining them afterward.

During totality, try these exposure times at ISO 100 and f/8:
1/4000, 1/2000, 1/1000, 1/250, 1/60, 1/30, 1/15, 1/4, 1/2, 1 sec, and 4 sec.

Disable camera/lens stabilization on a tripod!

PHOTOGRAPHY

PHOTOGRAPHY TIME

Set the camera to full-stop adjustments. It will reduce the time spent fiddling. As an example, the author tried the above shot sequence, adjusting the shutter speed as fast as possible.

It took thirty-three seconds to shoot the above 11 shots using 1/3-stop increments. This was without adjusting composition, focus, or anything else but the shutter speed. When the camera was set to full stop increments, it only took twenty-two seconds to step through the same shutter speed sequence. Use a remote release to reduce camera shake.

Assuming the totality lasts less than two minutes, only four shot sequences could be made using 1/3-stop increments. Yet six shot sequences could be made when the camera was set to full stop steps. Zero time was spent looking at the back LCD to analyze highlights and the histogram.

Now add in the bare minimum time to check the highlight warning. It took sixty-three seconds to shoot and check each image using full stops. And that was without changing the composition to allow for sun movement, bumping the tripod, etc. Looking at the LCD ("chimping") consumed **half** of the totality time.

This test was done in the comfort of home under no pressure. In real world conditions, it may be possible to successfully shoot only one sequence. If you plan to capture the entire dynamic range of the totality, you must practice the sequence until you have it down cold. If you normally fumble with your camera, do not underestimate the difficulty, frustration, and stress of total eclipse photography.

Most importantly, trying to shoot this sequence allowed for zero time to simply look at the totality to enjoy the spectacle.

AVOID LAST MINUTE PURCHASES

You should purchase whatever you think you'll need to photograph the eclipse early. This event will be nothing short of massive. Remember the hot toy of the year? Multiply that frenzy by a thousand. Everyone will want to try to capture their own photo.

Do not wait until the last few weeks before the eclipse to purchase cameras, lenses, filters, tripods, viewing glasses, and associated material. Consider that the totality of the eclipse will streak from

across America. Everyone who wants to photograph the eclipse will order at the same time. If you wait until too late to buy what you need, it's conceivable that solar filters to create a total eclipse photo will be sold out in the United States. All filters sold out during the 2017 total eclipse. Whether this happens or not, do not wait to make your purchases. It may be too late.

PRACTICE

You will need to practice with your equipment. Things may go wrong that you don't anticipate. If you've never photographed a partial or total eclipse, taking quality shots is more difficult than you think. Practice shooting the sequence with a midday sun. This will tell you if you have your exposures and timing correct. Figure out what you need well in advance.

Practice photographing the full moon and stars at night. Capture the moon in full daylight to learn how your camera reacts. Astrophotography is challenging and requires practice.

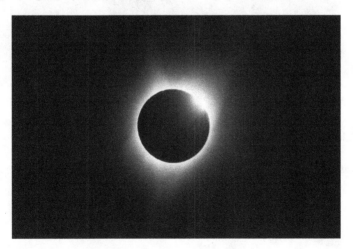

The August 21, 2017, eclipse as seen in Jackson, WY, shot with a Nikon D800 with an 80-400mm lens set to 340mm. The sun is 644 pixels wide on the 7360x4912 image.

This image is shown straight out of the camera without modification. Even with a high-quality camera and lens, photographing an eclipse is challenging.

PHOTOGRAPHY

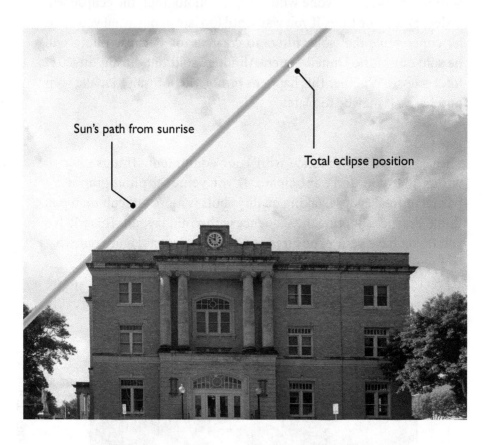

Sun's path from sunrise

Total eclipse position

The sun will follow this approximate path on the afternoon of the eclipse on April 8, 2024. Image of downtown McKinney, TX.

Note that this image is a simulation and approximation of where the total eclipse will appear. Refer to the eclipse position data for a more accurate location.

LOCATIONS

☉ is the symbol for the sun and first appeared in Europe during the Renaissance.
☾ is the ancient symbol for the moon.

Viewing Locations Around Texas

Tens of thousands of people will travel to and around Texas to view the total eclipse. There are few obstructions and there is a vast amount of space to view the total eclipse from.

If the weather is questionable, seek out a new location as soon as possible. If you wait until the hour before the eclipse, you may find yourself stuck in traffic, as others will be looking for a viewing location. Be safe on the roadways, as drivers may be distracted.

This section contains popular, alternative, and little-known locations to watch the eclipse. As long as there are no clouds or smoke from fires, the partial eclipse will be viewable from anywhere in the state.

SUGGESTED TOTAL ECLIPSE VIEW POINTS

TOWNS AND CITIES

- Austin
- Dallas
- Del Rio
- Fort Worth
- Hillsboro
- Kerville
- Paris

- San Antonio
- Sulphur Springs
- Temple
- Tyler
- Uvalde
- Waco

Texas Total
Eclipse Path

LOCATIONS

UNIQUE LOCATIONS

- Buchanan Lake
- Dinosaur Valley State Park
- Enchanted Rock State NA
- Garner State Park

- Lake Bardwell
- Lake Tawakoni State Park
- Lost Maples SNA
- Maverick Co. Airport

AUSTIN

Elevation:	489 feet
Population:	947,890
Main road/hwy:	Multiple

Austin

OVERVIEW

Austin, Texas is where Texans go on vacation. Not only is Austin the capital of Texas, but it's also the home to the University of Texas's main campus, a bustling business district and a diverse workforce. From Lake Travis to Lady Bird Lake to a night on the town, Austin has something for everyone. There are hiking trails for families and people who love the outdoors. If the great indoors is more your style, there's the LBJ Presidential Library and the Blanton Museum. You can live like a local when you plan your trip to Austin, Texas.

GETTING THERE

Austin is a major city in Texas and can be reached by multiple airlines and interstates.

TOTALITY DURATION

1 minutes 50 seconds

NOTES

Note that not all of the greater Austin metro area will experience the totality. Bluff Springs is on the edge. Head to northwest Austin for more time in the totality.

LOCATIONS

Event	Time (CDT)	Altitude	Azimuth
Sunrise	7:11:00AM	0°	80°
Eclipse Start	12:17:06PM	61°	138°
Totality Start	1:35:59PM	67°	182°
Totality End	1:37:50PM	67°	183°
Eclipse End	2:58:00PM	59°	225°
Sunset	7:54:00PM	0°	279°

DALLAS

Elevation:	430 feet	Dallas
Population:	1.3 million	
Main road/hwy:	Multiple	

OVERVIEW

Dallas has a rich history and a thriving, local scene. Both Dallas's Old City Hall and its current City Hall are stunning pieces of architecture. The city skyline is iconic, and most tourists take the time to pay their respects to John F. Kennedy and the grassy knoll. Whether you head north to see Southern Methodist University and the stunning homes of Highland Park or you venture into one of the suburbs of greater Dallas, there's something for everyone. You can travel by car or use the city's bus and tram system. Dallas is also home to the Dallas Mavericks NBA franchise. There's also a nearby Six Flags, and locals and tourists alike love to see the Texas Rangers play a home game in the Metroplex.

GETTING THERE

Dallas is a major city in Texas and can be reached by multiple airlines and interstates.

TOTALITY DURATION

3 minutes 50 seconds

NOTES

Visit www.visitdallas.com for updated information.

Event	Time (CDT)	Altitude	Azimuth
Sunrise	7:07:00AM	0°	81°
Eclipse Start	12:23:13PM	60°	145°
Totality Start	1:40:38PM	64°	186°
Totality End	1:44:29PM	64°	189°
Eclipse End	3:02:36PM	56°	226°
Sunset	7:52:00PM	0°	278°

LOCATIONS

Del Rio

Elevation:	997 feet
Population:	35,998
Main road/hwy:	US 90

Del Rio

Overview

Near the Texas-Mexico border, a visit to Del Rio gives visitors a trip to the heart of Texas. Del Rio has all the charm of a smaller city with the amenities of a large town. You might just get to see a plane fly overhead from nearby Laughlin Air Force Base. It's the largest pilot-training facility of the US Air Force. Make a relaxing visit to Lake Amistad, and pay a visit to historic and picturesque First United Methodist Church. You can fly into Del Rio via Del Rio International Airport, ride the Greyhound, take an Amtrak train ride, or go for a great Texas road trip before or after viewing the total eclipse.

Getting There

Drive west from Uvalde for seventy miles on US 90 to reach Del Rio.

Totality Duration

3 minutes 21 seconds

Notes

Visit Del Rio's website for updated eclipse information at www.cityofdelrio.com.

Event	Time (CDT)	Altitude	Azimuth
Sunrise	7:24:00AM	0°	80°
Eclipse Start	12:10:54PM	58°	129°
Totality Start	1:28:26PM	67°	169°
Totality End	1:31:51PM	68°	171°
Eclipse End	2:51:34PM	63°	219°
Sunset	8:06:00PM	0°	279°

FORT WORTH

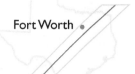

Elevation:	653 feet
Population:	854,113
Main road/hwy:	Multiple

OVERVIEW

In Fort Worth, you can enjoy the sights of the historic downtown and stockyards as well as marvel at a large, modern, Texas city. Fort Worth is home to Texas Christian University. You might be surprised to learn that Fort Worth is home to a location of the US Bureau of Engraving and Printing. You can drive around town or take the T, which is what the locals call the public transportation system. You can also take the train for a day-trip to Dallas. Fort Worth is near a major airport, and if you travel by plane you can get by without a car. Be aware that Forth Worth is on the northern edge of the eclipse path.

GETTING THERE

Fort Worth is a major city in Texas and can be reached by multiple airlines and interstates.

TOTALITY DURATION

2 minutes 30 seconds

NOTES

Be aware that the suburbs and communities northwest of Lake Worth will *not* see the totality. Eagle Mountain Lake is not in the path of totality.

Event	Time (CDT)	Altitude	Azimuth
Sunrise	7:07:00AM	0°	80°
Eclipse Start	12:22:24PM	60°	144°
Totality Start	1:40:22PM	64°	185°
Totality End	1:42:53PM	64°	187°
Eclipse End	3:01:42PM	57°	225°
Sunset	7:54:00PM	0°	279°

LOCATIONS

HILLSBORO

Elevation:	633 feet
Population:	8,362
Main road/hwy:	I-35E

Hillsboro

OVERVIEW

Located between Dallas and Waco, Hillsboro is 4.6 miles northwest of the totality centerline. The city has an active Hillsboro Historic Preservation Commission, so there's a long list of interesting places to see. From churches to the post office and even the county jail, it seems every building tells a story. Hillsboro has small town charm. It's famous for its collection of Victorian homes. You can shop in an antique store or take advantage of more modern shopping establishments. A few movies and television shows have been filmed in the town. You can also check out the Texas Musicians Museum before or after the eclipse.

GETTING THERE

Drive south from Dallas for sixty-one miles on I-35E to reach the town of Hillsboro.

TOTALITY DURATION

4 minutes 22 seconds

NOTES

Visit the town's website for updated eclipse information at: www.hillsborotx.org.

Event	Time (CDT)	Altitude	Azimuth
Sunrise	7:07:00AM	0°	80°
Eclipse Start	12:21:19PM	60°	143°
Totality Start	1:38:38PM	65°	185°
Totality End	1:43:01PM	65°	187°
Eclipse End	3:01:13PM	57°	225°
Sunset	7:53:00PM	0°	279°

LOCATIONS

KERRVILLE

Elevation:	1,637 feet
Population:	23,434
Main road/hwy:	I-10

Kerrville

OVERVIEW

If your eclipse plans include seeing Texas Hill Country, consider planning your visit to Kerrville, Texas. Kerrville is the county seat of Kerr County, Texas. Kerrville has carefully planned city parks, and nearby Guadalupe River attracts visitors year round. There are plenty of RV parks nearby if that's your preferred method of travel. The Museum of Western Art and Texas's Official State Arts & Crafts Fair are sure to entertain the whole family. There are interstates, highways, and other maintained roads to help you make Kerrville your eclipse home. A nearby bicycling route can entertain fitness enthusiasts. The city is only a few miles southeast of the eclipse centerline.

GETTING THERE

Drive northwest from San Antonio for sixty-six miles on I-10 to reach Kerrville.

TOTALITY DURATION

4 minutes 24 seconds

NOTES

Kerrville's website will have eclipse updates at www.kerrvilletx.gov.

Event	Time (CDT)	Altitude	Azimuth
Sunrise	7:16:00AM	0°	80°
Eclipse Start	12:14:39PM	60°	134°
Totality Start	1:32:00PM	67°	176°
Totality End	1:36:25PM	67°	178°
Eclipse End	2:55:25PM	61°	222°
Sunset	7:59:00PM	0°	279°

LOCATIONS

Paris

Elevation:	600 feet	
Population:	25,005	
Main road/hwy:	US 82	

Paris

Overview

No trip to Paris, Texas is complete without a trip to the Paris Eiffel Tower, complete with its red cowboy hat. Paris is about one hundred miles away from the Dallas-Fort Worth area. The city developed along railroad routes. It has historical homes that date back to the nineteenth century. Nearby Camp Maxey is an important training ground of the past and present US military. Paris, Texas is a great way to experience the eclipse without the hustle and bustle of the big city but close enough to enjoy all that the Metroplex has to offer. You can also take a trip to Oklahoma just to say you did.

Getting There

Drive northeast from Dallas on I-30 for fifty-five miles, then exit on TX-24 and continue for another forty-nine miles to reach Paris.

Totality Duration

4 minutes 0 seconds

Notes

Visit the Paris city website at www.paristexas.gov for eclipse updates as the city issues them.

Event	Time (CDT)	Altitude	Azimuth
Sunrise	6:59:00AM	0°	80°
Eclipse Start	12:26:37PM	60°	149°
Totality Start	1:43:53PM	63°	191°
Totality End	1:47:54PM	63°	193°
Eclipse End	3:05:28PM	54°	227°
Sunset	7:48:00PM	0°	279°

LOCATIONS

SAN ANTONIO

Elevation:	650 feet
Population:	1.49 million
Main road/hwy:	Multiple

OVERVIEW

San Antonio was the first city to formally become a municipality in the state of Texas. Since its days as a Spanish mission, it has grown to become one of the largest cities in Texas and in the entire United States. Whether you visit the historic Alamo or you take a stroll on the famed Riverwalk, you'll never run out of things to do. There are shops, downtown carriage rides, museums, and parks for you to choose from. The Riverwalk has shopping, places to eat, and even boat rides to enjoy before or after the eclipse. If you're looking for an amusement park, there are several choices: Six Flags Fiesta Texas, Morgan's Wonderland, and SplashTown. For the nature-loving crowd, there's the San Antonio Botanical Garden and the Japanese Tea Garden.

GETTING THERE

San Antonio is a major city in Texas and can be reached by multiple airlines and interstates.

TOTALITY DURATION

Zero to 1 minute 37 seconds (northwest suburbs only)

NOTES

Warning: Only the northwest section of the city will see the totality.

Event	Time (CDT)	Altitude	Azimuth
Sunrise	7:14:00AM	0°	80°
Eclipse Start	12:14:21PM	60°	134°
Totality Start	1:33:20PM	68°	178°
Totality End	1:34:57PM	68°	179°
Eclipse End	2:55:33PM	61°	224°
Sunset	7:56:00PM	0°	279°

LOCATIONS

Sulphur Springs

Elevation:	502 feet
Population:	16,162
Main road/hwy:	I-30

Sulphur Springs

Overview

Like the name sounds, the early settlers of Sulphur Springs found many natural springs in the area. The town grew in the nineteenth century. For an eclipse visit, there's all kinds of fun to be had. The city has a modern splash pad and a sprawling courthouse lawn. Or you can take advantage of nearby Lake Fork and Cooper Lake State Park. Coleman Lake and Park is another great option with waterfalls, and Buford Park has a large children's play area. If you prefer to spend your eclipse trip in the great outdoors, Sulphur Springs is an option you should seriously consider. Come see why early settlers called this city the Bright Star.

Getting There

Drive northeast from Dallas for seventy-four miles on I-30 to reach Sulphur Springs.

Totality Duration

4 minutes 20 seconds

Notes

Visit the Sulphur Springs website for eclipse updates at www.sulphurspringstx.org.

Event	Time (CDT)	Altitude	Azimuth
Sunrise	7:00:00AM	0°	80°
Eclipse Start	12:25:35PM	61°	148°
Totality Start	1:42:51PM	64°	190°
Totality End	1:47:12PM	63°	193°
Eclipse End	3:04:50PM	55°	228°
Sunset	7:48:00PM	0°	279°

TEMPLE

Elevation:	719 feet
Population:	73,600
Main road/hwy:	I-35

OVERVIEW

For eclipse viewers, Temple offers a viewing location that's large enough to have big-city amenities but small enough to be away from the bustle of major metropolitan areas. Temple is also a great home base for day-trips to Dallas, Houston, San Antonio and Waco. Temple has a rich history, and you can learn about it with a trip to the Temple Railroad and Heritage Museum. Organizers regularly plan public concerts and events for kids. Community parks have athletic fields and facilities, playgrounds, and even swimming areas. Eclipse viewers can also enjoy an impressive public trail network.

GETTING THERE

Drive north on I-35 for sixty-eight miles from Austin to reach the city of Temple.

TOTALITY DURATION

3 minutes 45 seconds

NOTES

Visit Temple's website at www.ci.temple.tx.us for eclipse updates.

Event	Time (CDT)	Altitude	Azimuth
Sunrise	7:08:00AM	0°	80°
Eclipse Start	12:19:17PM	61°	140°
Totality Start	1:37:06PM	66°	183°
Totality End	1:40:52PM	66°	186°
Eclipse End	2:59:44PM	58°	226°
Sunset	7:53:00PM	0°	279°

LOCATIONS

TYLER

Elevation:	544 feet
Population:	104,798
Main road/hwy:	US 69

OVERVIEW

If you're looking for a unique eclipse experience, take a trip to the Rose Capital of the World. Tyler has the largest rose garden in the country. It's more than fourteen acres, and it has more than five hundred varieties of roses. The University of Texas has a Tyler campus with a number of landmarks to see including Riter Millennium Bell Tower. Take your family to the Caldwell Zoo or a nearby indoor water park. Tyler State Park has a wide variety of outdoor attractions. There are places for camping that are sure to fill for the eclipse. With more than twenty thousand college students living in Tyler, there's always a sense of excitement in the city. Tyler, Texas gets its name from US President John Tyler.

GETTING THERE

Drive east from Dallas on I-20 for ninety miles, then continue south on US 69 for another ten miles to reach Tyler.

TOTALITY DURATION

2 minutes 32 seconds

NOTES

Visit Tyler's website at www.cityoftyler.org for eclipse updates.

Event	Time (CDT)	Altitude	Azimuth
Sunrise	6:59:00AM	0°	80°
Eclipse Start	12:24:45PM	61°	148°
Totality Start	1:43:10PM	64°	191°
Totality End	1:45:43PM	64°	193°
Eclipse End	3:04:31PM	55°	229°
Sunset	7:46:00PM	0°	279°

Uvalde

Elevation:	909 feet
Population:	16,540
Main road/hwy:	US 90

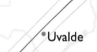

Overview

Take a trip to southern Texas and view the eclipse from the small city of Uvalde. Uvalde borders the Texas Hill Country, and locals call it the Honey Capital of the World. Don't forget to snap a photo in front of the historic Grand Opera House that has been preserved and restored. There are also a number of beautiful churches that are worth a photograph. Check out the Briscoe Art & Antique Collection and the Aviation Museum of Texas at Garner Field. There is a town square and a beautiful fountain. The Sahawe Outdoor Theater hosts Sahawe Native American dances for everyone to enjoy and celebrate the heritage of the natives in the region. There's plenty of green space in the town for you to find the perfect spot to view the eclipse.

Getting There

Drive west on US 90 for eighty-three miles from San Antonio to reach Uvalde.

Totality Duration

4 minutes 16 seconds

Notes

Uvalde's website will have eclipse updates at www.uvaldetx.com.

Event	Time (CDT)	Altitude	Azimuth
Sunrise	7:20:00AM	0°	80°
Eclipse Start	12:12:06PM	59°	131°
Totality Start	1:29:33PM	68°	172°
Totality End	1:33:49PM	68°	175°
Eclipse End	2:53:12PM	62°	221°
Sunset	8:01:00PM	0°	279°

LOCATIONS

WACO

Elevation:	470 feet	
Population:	134,432	
Main road/hwy:	I-35	

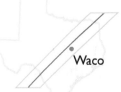

OVERVIEW

There's so much to do in Waco that your only problem is going to be narrowing it down. Start with the Dr. Pepper Museum and then stop for a photo at the McLennan County Courthouse. Enjoy the Texas Ranger Hall of Fame and Museum and plan a visit to the Waco Mammoth National Monument. No trip to Waco is complete without paying homage to Baylor University's beautiful campus and stunning athletic fields. Waco is far from just a university town. The locals are proud of the Waco Suspension Bridge and the Hawaiian Falls Water-park. Waco is just a few hours from Dallas or Austin.

GETTING THERE

Drive north on I-35 from Austin for one hundred two miles to reach Waco.

TOTALITY DURATION

4 minutes 12 seconds

NOTES

Check Waco's website at www.waco-texas.com for eclipse safety and lodging updates.

LOCATIONS

Event	Time (CDT)	Altitude	Azimuth
Sunrise	7:07:00AM	0°	80°
Eclipse Start	12:20:24PM	61°	142°
Totality Start	1:37:55PM	66°	184°
Totality End	1:42:07PM	65°	187°
Eclipse End	3:00:35PM	58°	226°
Sunset	7:53:00PM	0°	279°

Dinosaur Valley SP

Elevation:	790 feet
Main road/hwy:	US 67

Dinosaur Valley
State Park

Overview

If you prefer to view the eclipse surrounded by nature, Dinosaur Valley State Park is sure to be a hit. The Paluxy River headlines the state park. The park gets its name because of dinosaur tracks found in the area in the early 1900s. Some say that at least some of the tracks are a hoax and invented by opportunists during the 1930s in order to make a buck during the Great Depression. You can camp at the park or go for a picnic. There are even places where you can bring your own horse. There are also tour companies for assisted trail rides.

Getting There

Drive south from Fort Worth on the Chisholm Trail Pkwy for fifty-three miles which merges into US 67 at Cleburne, then continue west and exit on FM-205N to reach the park.

Totality Duration

2 minutes 53 seconds

Notes

Visit the state park website at tpwd.texas.gov/state-parks/dinosaur-valley for updated eclipse visitation and camping information.

LOCATIONS

Event	Time (CDT)	Altitude	Azimuth
Sunrise	7:09:00AM	0°	80°
Eclipse Start	12:20:47PM	60°	141°
Totality Start	1:38:38PM	65°	183°
Totality End	1:41:31PM	65°	185°
Eclipse End	3:00:22PM	58°	224°
Sunset	7:56:00PM	0°	279°

ENCHANTED ROCK SNA

Elevation: 1,501 feet
Main road/hwy: TX-16

Enchanted Rock
State Natural Area

OVERVIEW

What could be a more memorable eclipse experience than viewing it from the top of the famed ancient dome in the Enchanted Rock State Natural Area? If you love hiking, climbing, backpacking, and enjoying the great outdoors, this is the choice for you. There are a few pet restrictions to be aware of as you plan. A few different organizations lead guided tours of the area, or you can go it alone. Nearby Fredericksburg offers all of the amenities of a city vacation including dining and shopping. You can learn a lot about US President Lyndon B. Johnson on a trip to the Enchanted Rock State Natural Area because he was born nearby.

GETTING THERE

Drive northwest from Austin on TX-71W, then turn south on TX-16, and then turn west on Ranch Rd 965. Total distance: ninety-six miles.

TOTALITY DURATION

4 minutes 24 seconds

NOTES

Visit Enchanted Rock's website for updated eclipse information at tpwd.texas.gov/state-parks/enchanted-rock.

Event	Time (CDT)	Altitude	Azimuth
Sunrise	7:15:00AM	0°	80°
Eclipse Start	12:16:01PM	60°	136°
Totality Start	1:33:20PM	67°	177°
Totality End	1:37:45PM	67°	180°
Eclipse End	2:56:34PM	60°	223°
Sunset	7:58:00PM	0°	279°

LOCATIONS

Garner State Park

Elevation:	1,434 feet
Main road/hwy:	TX-127

Garner SP

Overview

Garner State Park is one of the few parks in Texas directly under the centerline of the 2024 total eclipse. The Frio River meanders through the park, providing interesting viewing and photography locations. The park offers multiple options for camping: screened shelters, cabins, or campsites. If you plan to reserve a shelter or group campsite, do so as early as possible. Once word spreads about the total eclipse, reservations will disappear rapidly.

Getting There

Drive west on US 90 from San Antonio, then turn northwest on TX-127 at Sabinal to reach the park. Note that this route may be partly on private roads.

Totality Duration

4 minutes 26 seconds

Notes

Visit the park's website at tpwd.texas.gov/state-parks/garner to reserve your campsite as soon as possible.

LOCATIONS

Event	Time (CDT)	Altitude	Azimuth
Sunrise	7:19:00AM	0°	80°
Eclipse Start	12:12:56PM	59°	132°
Totality Start	1:30:14PM	67°	173°
Totality End	1:34:40PM	67°	176°
Eclipse End	2:53:49PM	62°	221°
Sunset	8:01:00PM	0°	279°

Lake Bardwell

Elevation:	421 feet	Lake Bardwell
Main road/hwy:	TX-34	

Overview

Located in Ellis County, Lake Bardwell is directly under the path of the eclipse on April 8, 2024. This 3,138-acre body of water is less than an hour south of Dallas and will be a good place to escape the crowds of the big city for the eclipse. Popular with anglers, this man-made reservoir offers excellent eclipse-viewing locations from nearly the entire lake. Originally built by the US Army Corp of Engineers to reduce flood damage to the county, the lake is visited year-round.

Getting There

Drive south from Dallas on I-45, then turn southwest at Ennis on TX-34 to reach the reservoir.

Totality Duration

4 minutes 22 seconds

Notes

Permits are required for large events, including setting up bounce houses, slides, and the like. Visit the reservoir's website for an activity request form at www.swf-wc.usace.army.mil/bardwell.

<div style="writing-mode: vertical">LOCATIONS</div>

Event	Time (CDT)	Altitude	Azimuth
Sunrise	7:05:00AM	0°	80°
Eclipse Start	12:22:29PM	60°	144°
Totality Start	1:39:48PM	65°	186°
Totality End	1:44:10PM	65°	189°
Eclipse End	3:02:14PM	65°	226°
Sunset	7:51:00PM	0°	279°

LAKE BUCHANAN

Elevation:	1,020 feet	
Population:	1,688	Lake Buchanan
Main road/hwy:	TX-29	

OVERVIEW

If you prefer a beautiful lake surrounded by Texas Hill Country, you may want to take in the eclipse from Buchanan Lake. Sure to be a popular eclipse destination, Lake Buchanan is a hot spot for fishing, boating, and swimming. There are places for you to camp, or you can rent a home or cabin. It's a large lake, so it should be able to handle large crowds. At its widest point, it's a little bit less than five miles across. The shoreline is more than one hundred miles long, and there's also a private lighthouse that's worth a visit. There are friendly locals who live in the surrounding areas.

GETTING THERE

Drive north from Austin on US 183 for twenty-five miles, then turn west on TX-29 and drive another thirty miles to reach Lake Buchanan.

TOTALITY DURATION

4 minutes 24 seconds

NOTES

The lake lies directly on the eclipse centerline. Visit their website for eclipse camping and visitation updates at www.lake-buchanan.com.

LOCATIONS

Event	Time (CDT)	Altitude	Azimuth
Sunrise	7:13:00AM	0°	80°
Eclipse Start	12:17:06PM	60°	137°
Totality Start	1:34:26PM	66°	179°
Totality End	1:38:51PM	66°	182°
Eclipse End	2:57:34PM	59°	223°
Sunset	7:57:00PM	0°	279°

Lake Tawakoni State Park

Elevation: 438 feet
Main road/hwy: US 276

Lake Tawakoni
State Park

Overview

Situated near Wills Point east of Dallas, Lake Tawakoni State Park has swimming, fishing, and more. Lake Tawakoni State Park has a beautiful, large forest for you to explore. There's also a network of more than five miles of trails. There's even fishing gear that you can rent to go out and make that perfect catch during your visit. The park has a shop where you can buy camping supplies such as wood, ice, and snacks. There are also souvenirs so that you can remember the occasion. The park has a number of different campsites. The campsites range from bare bones to fully stocked.

Getting There

Drive east from Dallas on I-30/US 80 for thirty-two miles, then turn northeast on Farm to Market 429 road for twenty-two miles.

Totality Duration

4 minutes 21 seconds

Notes

The lake is directly on the totality centerline. There are multiple access routes to the lake.

Event	Time (CDT)	Altitude	Azimuth
Sunrise	7:01:00AM	0°	80°
Eclipse Start	12:24:37PM	61°	147°
Totality Start	1:41:53PM	64°	185°
Totality End	1:46:15PM	64°	191°
Eclipse End	3:04:01PM	55°	227°
Sunset	7:49:00PM	0°	279°

Lost Maples SNA

Elevation:	2,238 feet	Lost Maples State
Main road/hwy:	FM-187	Natural Area

Overview

Located three miles from the eclipse centerline, this recreation area was originally established to protect a unique stand of Uvalde bigtooth maples. The park even has a 2,200-foot cliff. It's possible to camp in thirty campsites with running water and electricity. For those looking for a backcountry experience, there are six primitive campsites available. Should you plan to camp at the park, make your reservations as early as possible. The 2017 total eclipse taught America that outdoor recreation sites along the eclipse path will fill rapidly.

Getting There

Drive north from San Antonio on I-10, then turn southwest on TX-39, and finally south on FM-187 to reach the park.

Totality Duration

4 minutes 25 seconds

Notes

Visit the park's website for updated information at tpwd.texas.gov/state-parks/lost-maples. Cell phone service is unavailable in this area.

Event	Time (CDT)	Altitude	Azimuth
Sunrise	7:18:00AM	0°	80°
Eclipse Start	12:13:36PM	59°	133°
Totality Start	1:30:53PM	67°	174°
Totality End	1:35:19PM	67°	177°
Eclipse End	2:54:24PM	61°	221°
Sunset	8:01:00PM	0°	279°

LOCATIONS

MAVERICK COUNTY MEMORIAL INTERNATIONAL AIRPORT

Elevation:	883 feet
Main road/hwy:	US 227

Maverick
Airport

OVERVIEW

If you want to view the total eclipse at the first location in the continental United States, then make your way south to this airport. Located only three miles north of the Mexican border, Maverick County's airport affords eclipse chasers the chance to see the total eclipse shadow at the first contact point in the country. Note that the airport may be inundated with eclipse chasers. Airports under the 2017 total eclipse established special safety restrictions, so expect possible access restrictions for Maverick airport as well.

GETTING THERE

Drive southeast from Del Rio on US 277 to reach the airport.

TOTALITY DURATION

4 minutes 26 seconds

NOTES

Call the airport at (830) 773-9636 or visit their website at www.co.maverick.tx.us/default.aspx?Maverick_County/Airport for updated eclipse access information.

<div style="writing-mode: vertical">LOCATIONS</div>

Event	Time (CDT)	Altitude	Azimuth
Sunrise	7:23:00AM	0°	81°
Eclipse Start	12:10:24PM	59°	129°
Totality Start	1:27:38PM	68°	169°
Totality End	1:32:05PM	68°	172°
Eclipse End	2:51:28PM	63°	220°
Sunset	8:04:00PM	0°	279°

REMEMBER THE TEXAS TOTAL ECLIPSE
April 8, 2024

Who was I with? _____

What did I see? _____

What did I feel? _____

What did the people with me think? _____

Where did I stay?_____

Enjoy Other Titles by Aaron Linsdau

2024 Total Eclipse Series

Sastrugi Press has published guides for the 2024 total eclipse crossing over the United States, Mexico, and Canada. Visit the Sastrugi Press website for the available 2024 total eclipse books: www.sastrugipress.com/eclipse.

50 Jackson Hole Photography Hotspots

This guide reveals the best Jackson Hole photography spots. Learn what locals and insiders know to find the most impressive and iconic photography locations in the United States. This is an excellent companion guide to the *Jackson Hole Hiking Guide*.

Adventure Expedition One
by Aaron Linsdau M.S. & Terry Williams, M.D.

Create, finance, enjoy, and return safely from your first expedition. Learn the techniques explorers use to achieve their goals and have a good time doing it. Acquire the skills, find the equipment, and learn the planning necessary to pull off an expedition.

Antarctic Tears

Experience the honest story of solo polar exploration. This inspirational true book will make readers both cheer and cry. Coughing up blood and fighting skin-freezing temperatures were only a few of the perils Aaron Linsdau faced. Travel with him on a world-record expedition to the South Pole.

How to Keep Your Feet Warm in the Cold

Keep your feet warm in cold conditions on chilly ad- ventures with techniques described in this book. Packed with dozens and dozens of ideas, learn how to avoid having cold feet ever again in your outdoor pursuits.

Jackson Hole Hiking Guide

Jackson Hole contains some of the most dramatic and iconic landscapes in the United States. The book shares everything you need to know to hike Jackson's classic trails with canyons, high mountains, and hidden alpine lakes. This book is an excellent companion guide to *50 Jackson Hole Photography Hotspots*.

Lost at Windy Corner

Windy Corner on Denali has claimed fingers, toes, and even lives. What would make someone brave lethal weather, crevasses, and avalanches to attempt to summit North America's highest mountain? Aaron Linsdau shares the experience of climbing Denali alone and how you can apply the lessons to your life.

The Most Crucial Knots to Know

Knot tying is a skill everyone can use in daily life. This book shows how to tie over 40 of the most practical knots for virtually any situation. This guide will equip readers with skills that are useful, fun to learn, and will make you look like a confident pro.

The Motivated Amateur's Guide to Winter Camping

Winter camping is one of the most satisfying ways to experience the wilderness. It is also the most challenging style of overnighting in the outdoors. Learn 100+ tips from a professional polar explorer on how to winter camp safely and be comfortable in the cold.

Use your smart device to scan the QR codes for website links.

Visit www.aaronlinsdau.com/subscribe/ to join his email list. Receive updates when he releases new books and shows.

Visit Sastrugi Press on the web at www.sastrugipress.com to purchase the above titles in bulk. They are available in print, e-book, or audiobook form.

Thank you for choosing Sastrugi Press.
"Turn the Page Loose"

About Aaron Linsdau, Polar Explorer & Motivational Speaker

Aaron Linsdau is the second American to ski alone from the coast of Antarctica to the South Pole (730 miles / 1174 km), setting a world record for surviving the longest expedition ever for that trip.

He lead a 310-mile (499 km) ski expedition across the Greenland icecap along the Arctic Circle. Aaron has walked across Yellowstone National Park in winter, crossed the Greenland tundra alone, trekked through the Sahara desert, climbed on Denali solo, and successfully climbed Mt. Kilimanjaro and Mt. Elbrus in Russia.

He is an Eagle Scout and has received the Outstanding Eagle Scout Award. He holds a bachelor's degree in electrical engineering and a master's degree in computational science. Some of Aaron's books include *Antarctic Tears*, *Lost at Windy Corner*, *Adventure Expedition One*, *How to Keep Your Feet Warm in the Cold*, *Jackson Hole Hiking Guide*, and *The Most Crucial Knots to Know*. He is also the author of the *2024 Total Eclipse Guide* series.

Aaron is a professional photographer with two decades of experience. His landscape photography work reflects his desire to help others appreciate nature in its rawest forms.

Visit and subscribe to Aaron's YouTube channel at:
www.youtube.com/@alinsdau

"NEVER GIVE UP"
ADVERSITY • ATTITUDE • RESILIENCE • RISK • SAFETY

Read reviews, be inspired, and learn more about Aaron Linsdau at:
www.aaronlinsdau.com

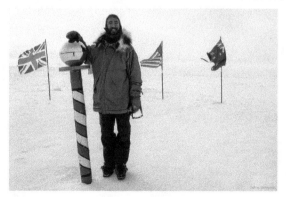

Smart device link
aaronlinsdau.com

Aaron at the South Pole after 82 days alone in Antarctica.

9 781944 986230